院 囍

DOUBLE
HAPPINESS
IN A
COURTYARD

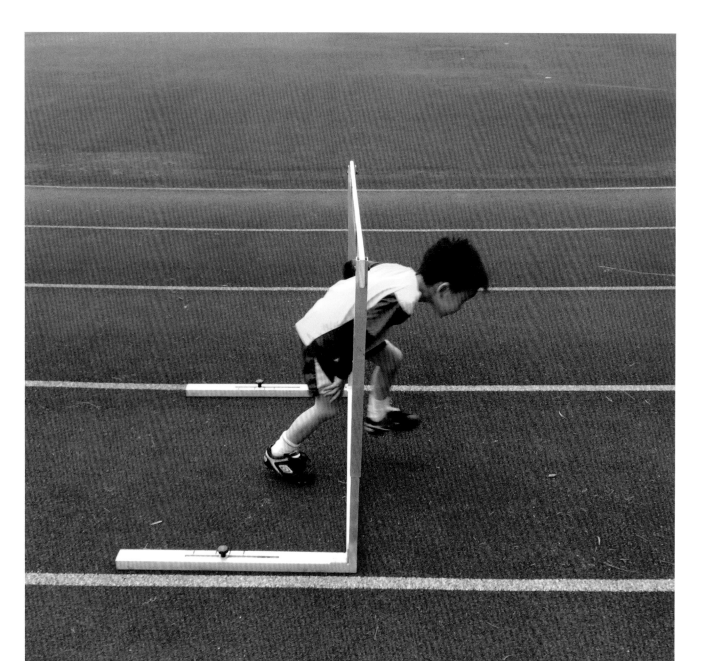

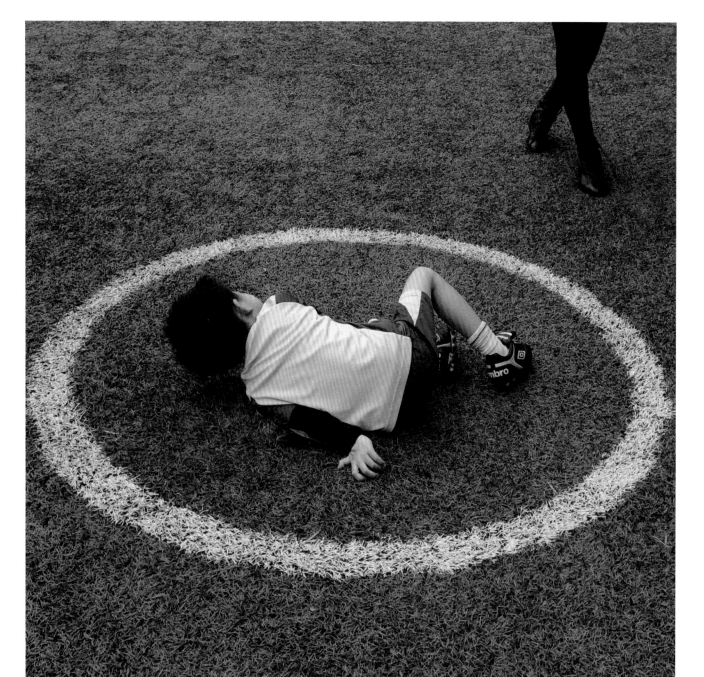

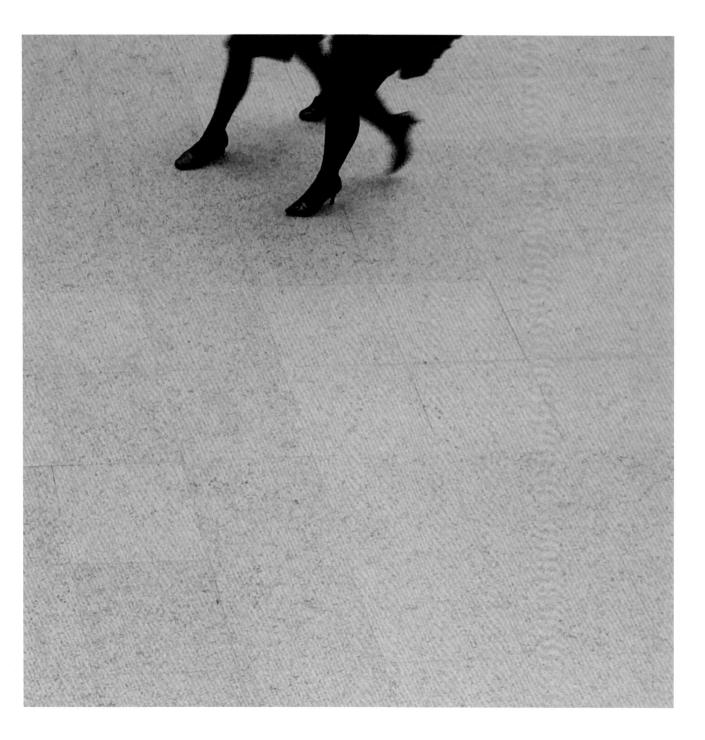

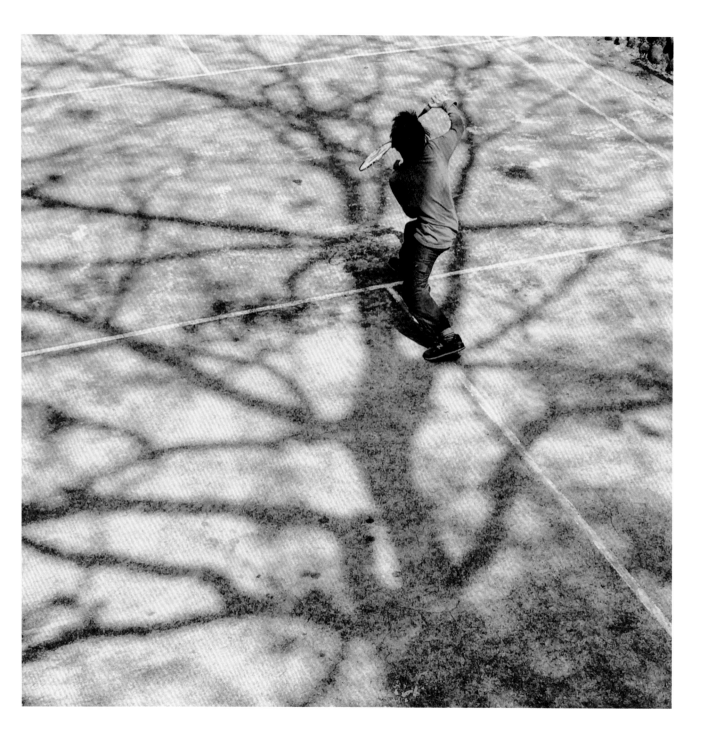

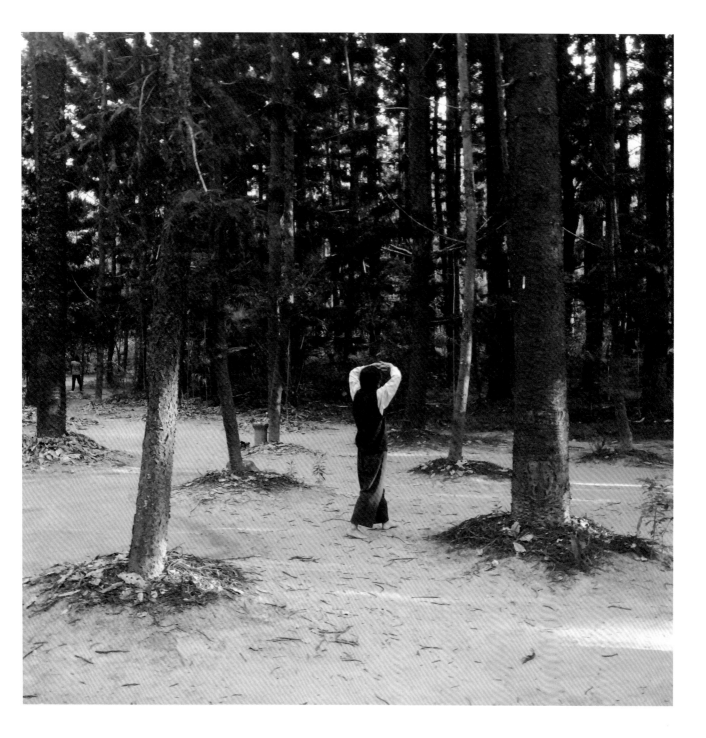

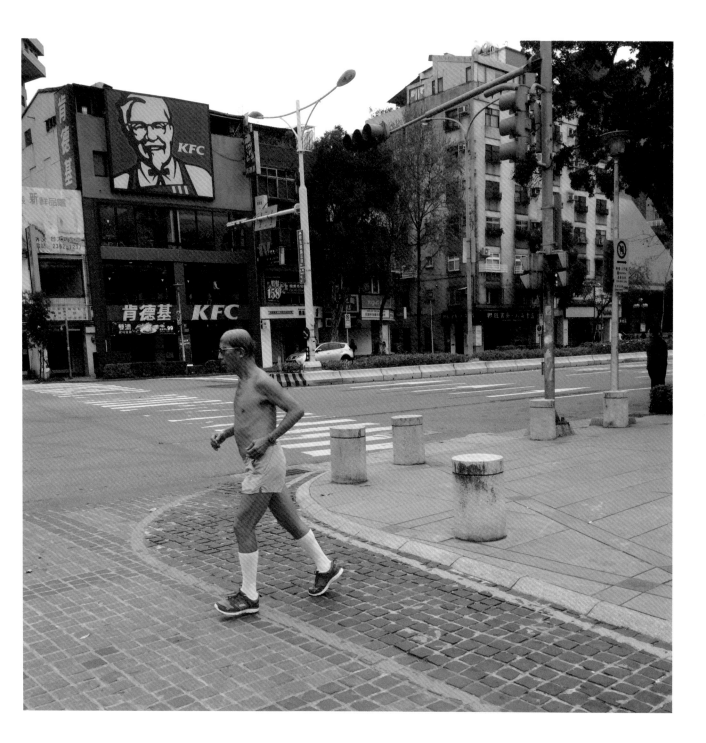

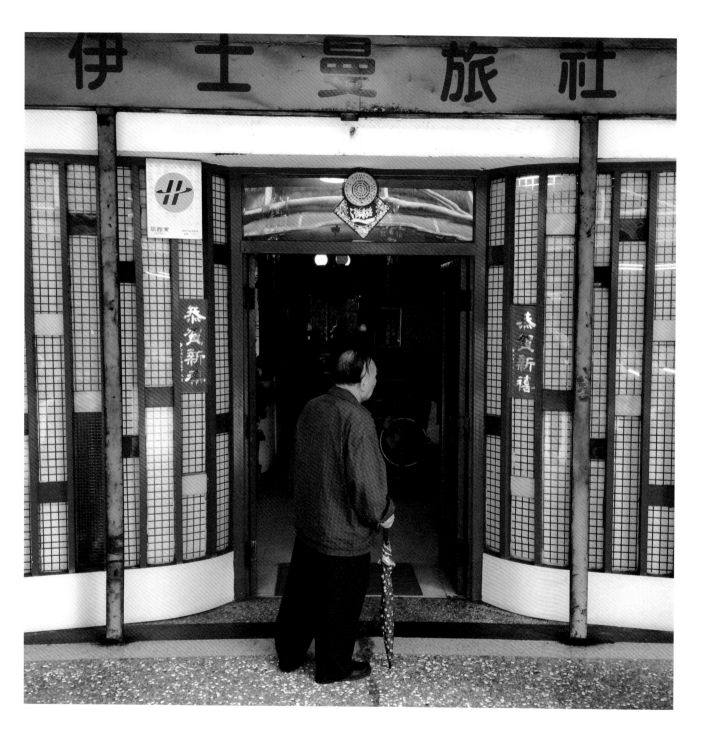

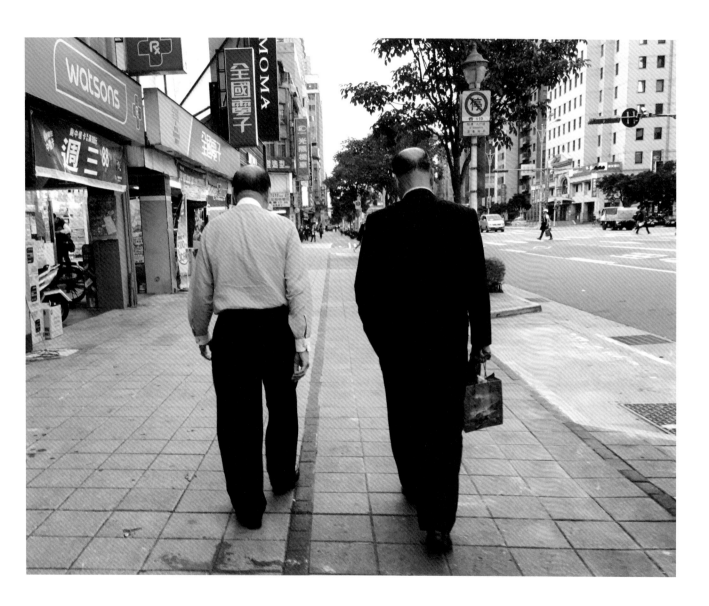

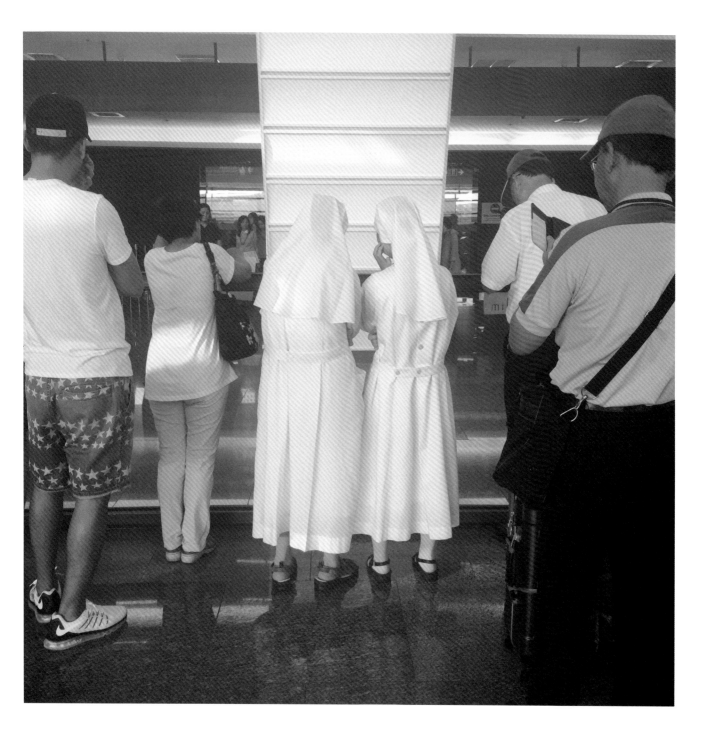

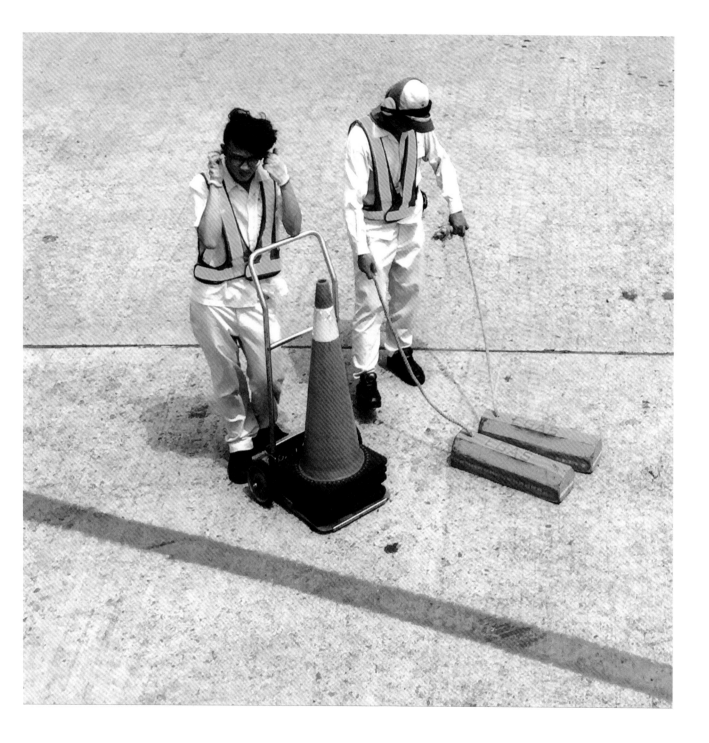

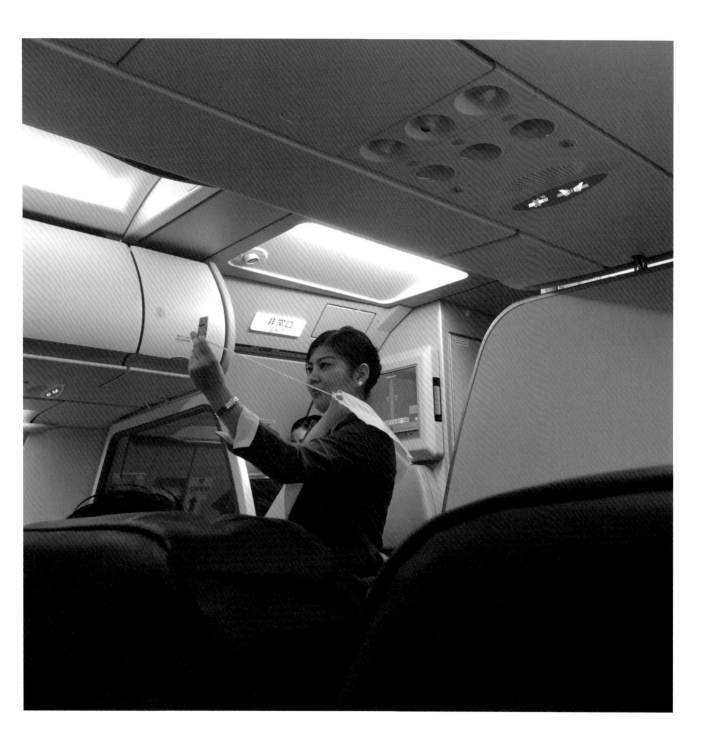

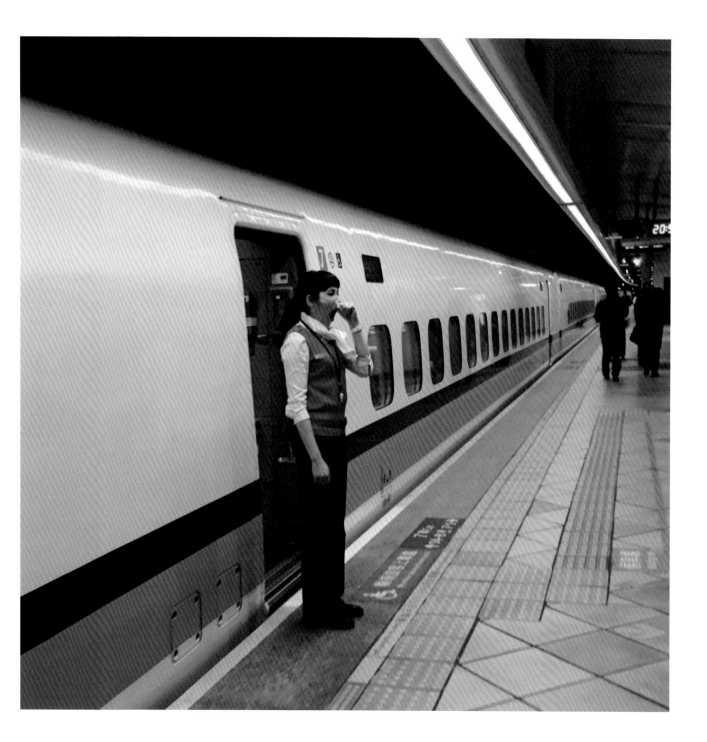

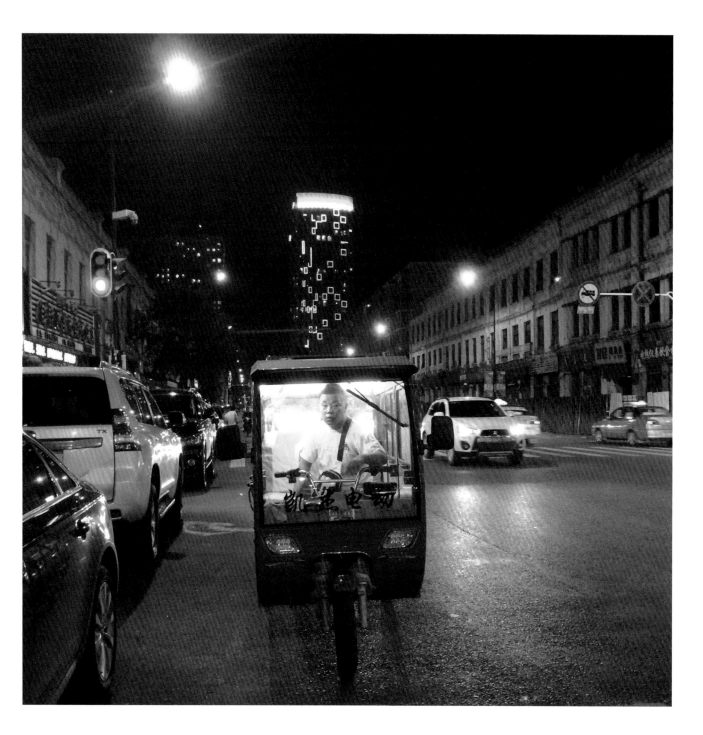

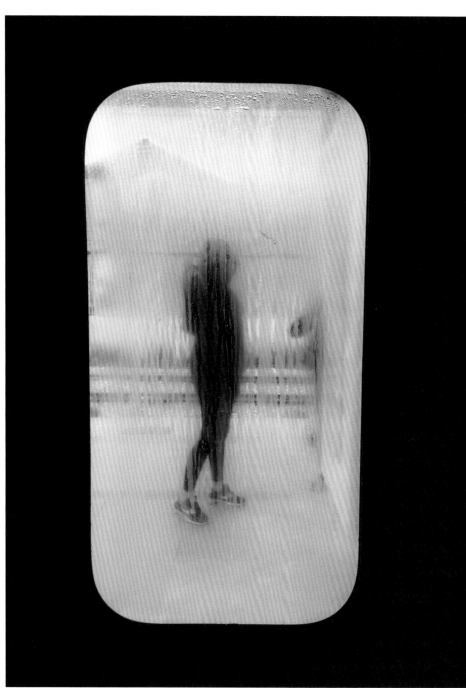

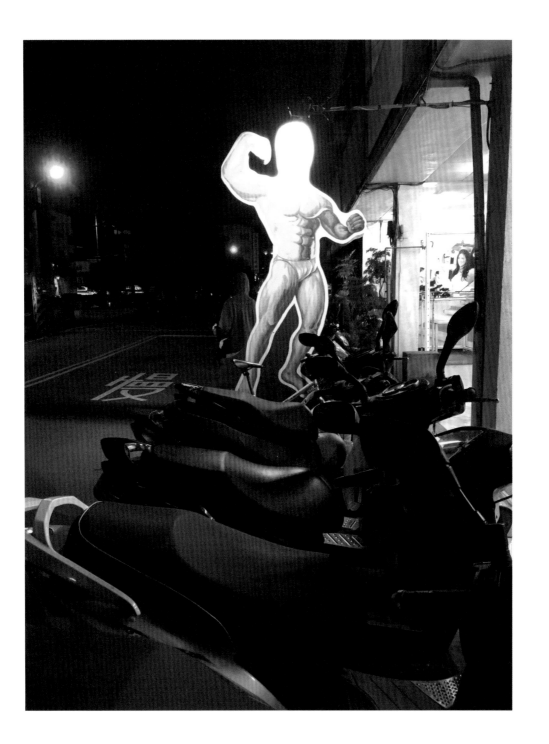

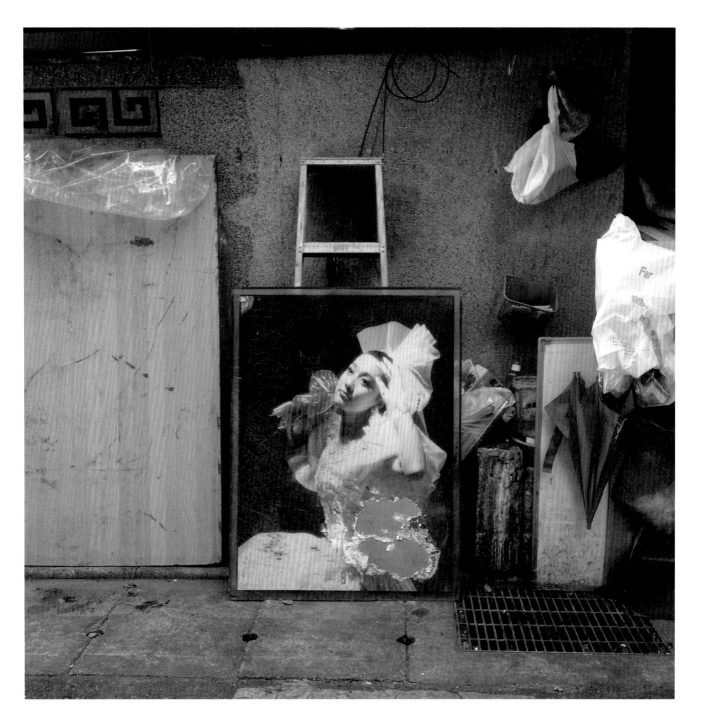

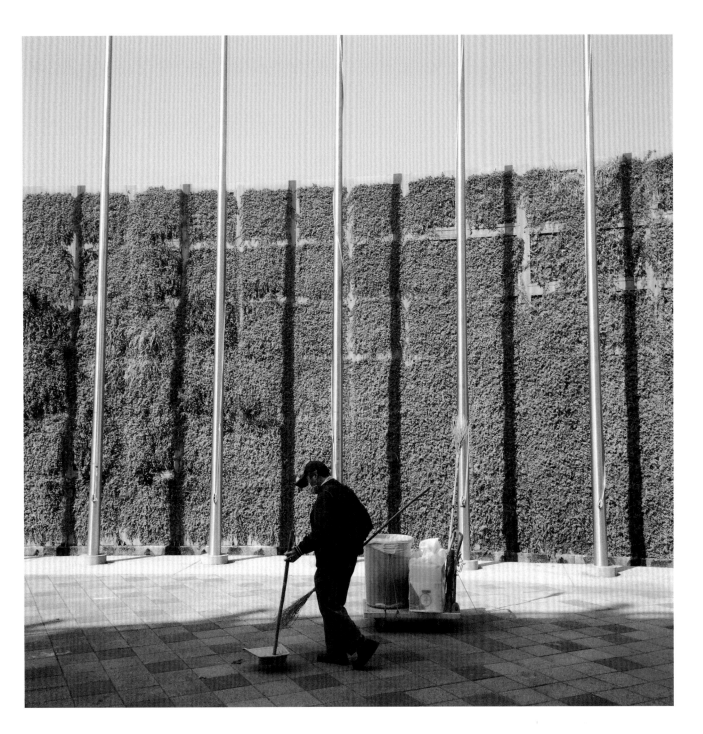

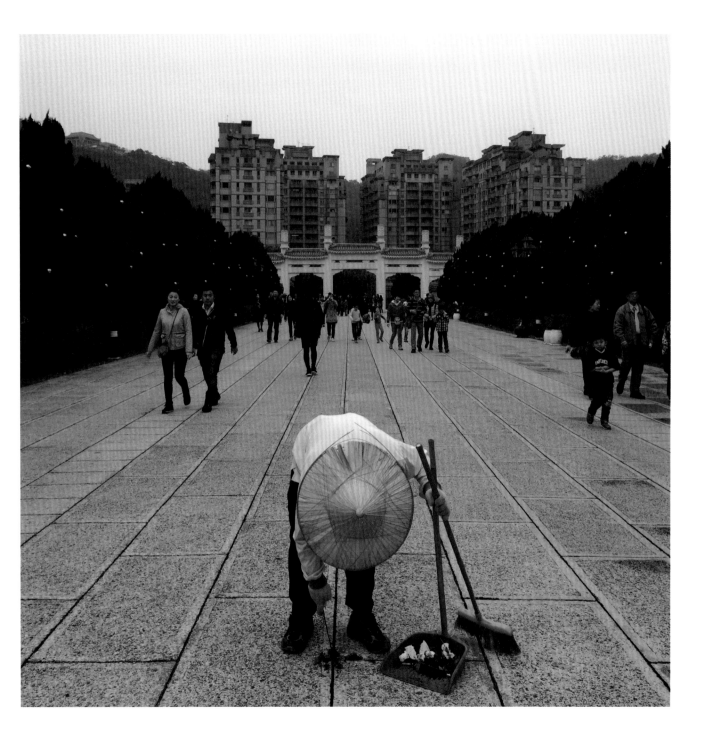

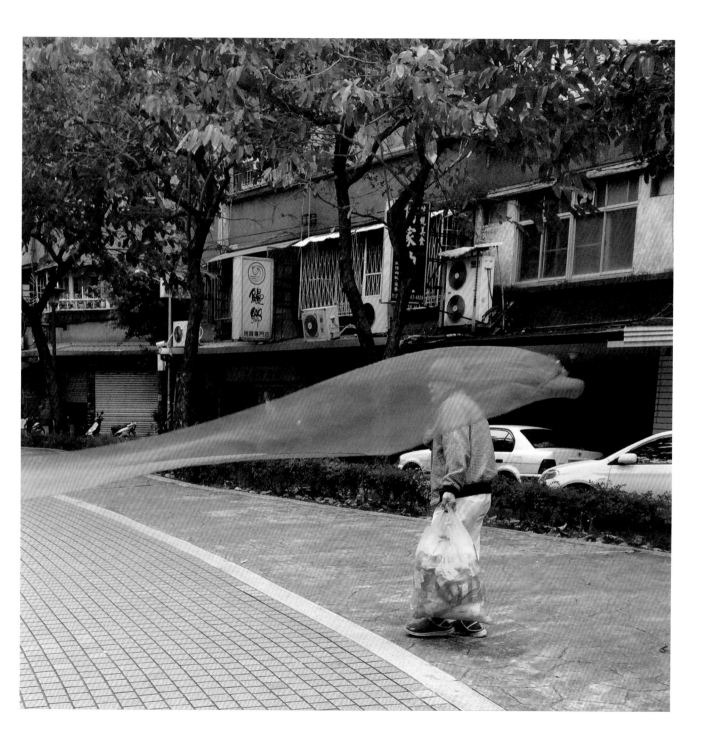

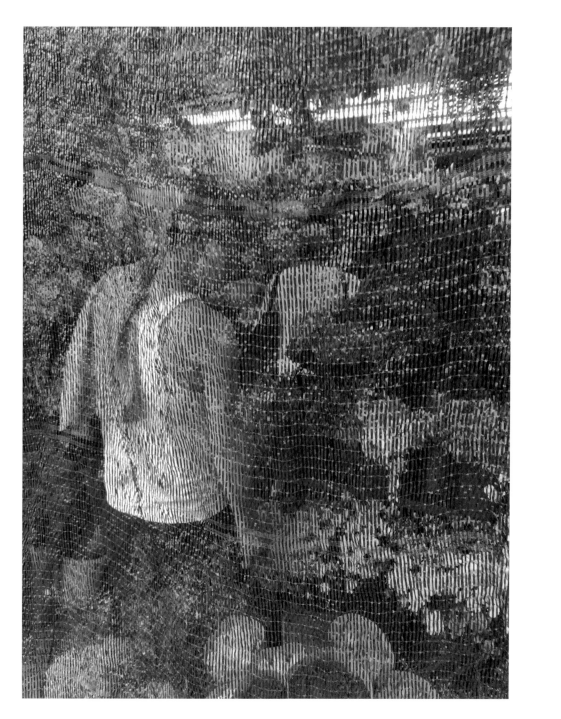

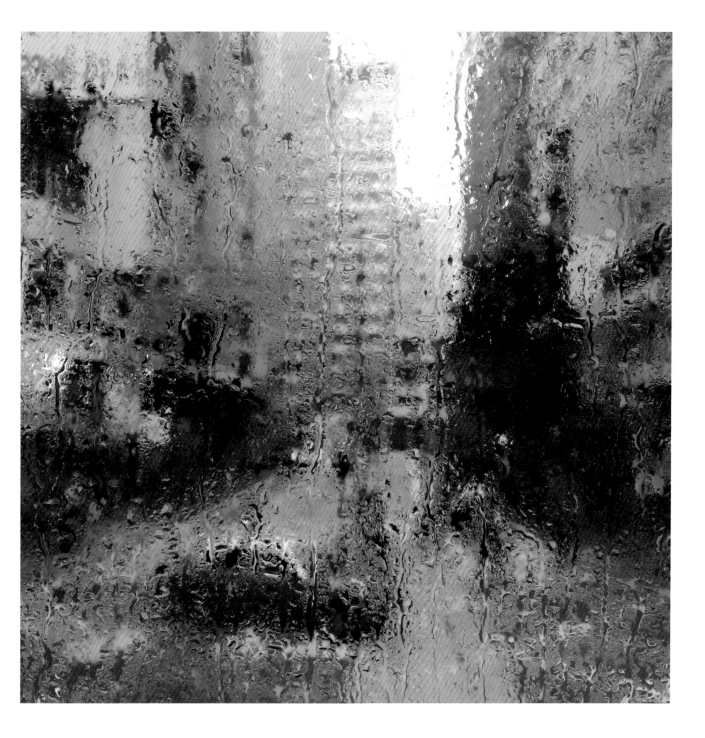

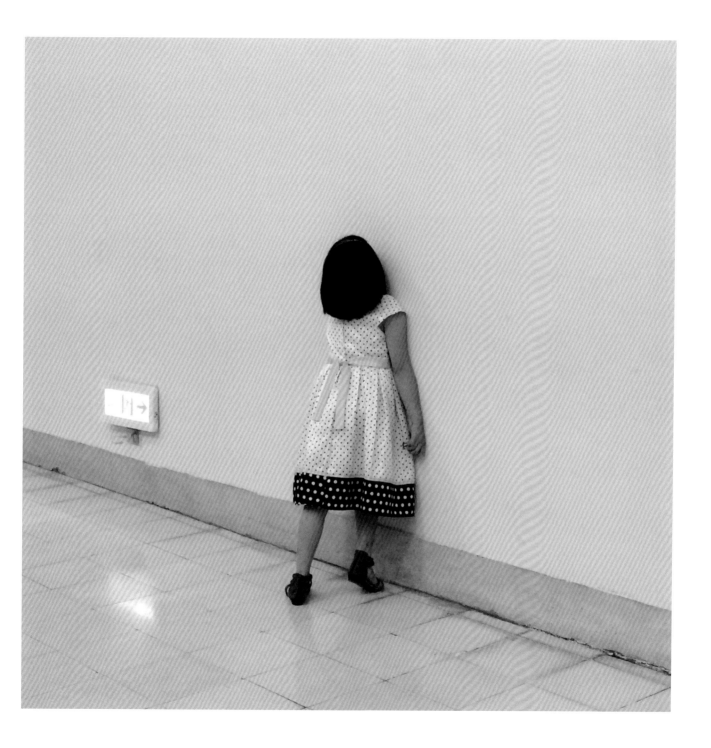

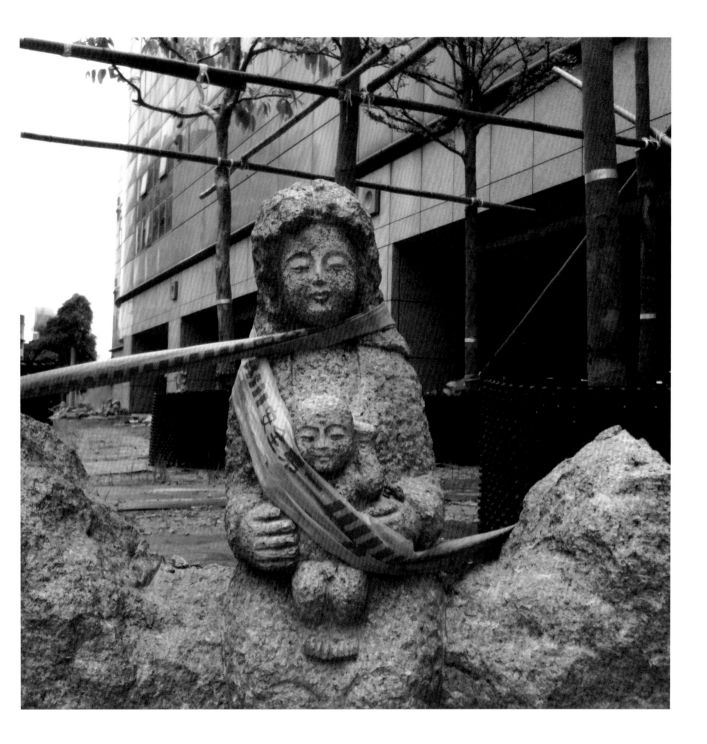

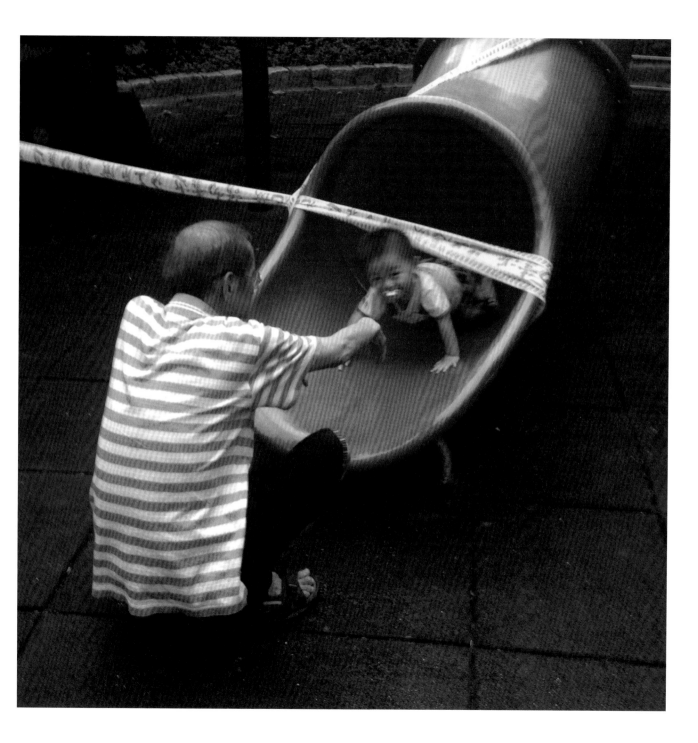

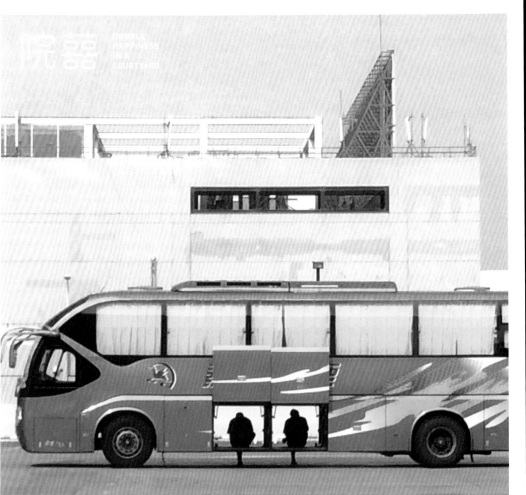

院囍　JUAN SEA ——————————— 2016 - 2017　新書攝影個展　PHOTO EXHIBITIONS

《 院囍 · Double Happiness in a Courtyard 》

精緻的幽默
比深刻的悲傷
更罕有。

「我的照片比較偏向詼諧幽默，但重點還是在表達人與人之間的情感，一種溫度的表現。……把一個人拍得美之前，我會先把他拍得好笑。」 ——— 阮璽

他在不同都市的「大院子」之間穿梭，用手機記錄下幽默豐富的城市生活，作品總能令人莞爾一笑，但緊接著便是深深的思索。

他的攝影新作《院囍》，畫面中彷彿聽到他在街頭走動的輕快步伐，也許還會不經意發現，他正躲在角落，窺視屬於這個世代的詼諧天地。

阮璽 · 攝影師，1981年生於台北。
阮義忠攝影工作坊台北經營人、各教育機構大專院校攝影講師。

做了13年各種類型的業務，2012年開始拿起手機拍照，2015年出版第一本攝影集後正式以攝影師身分出道，從此生命180度轉變；夢想跑遍全台灣做攝影教學分享，目前愛用底片機拍照，希望第三本攝影集為全底片創作。

獲《China Post》《大成報》《自由時報》《杭州都市報》《光明日報》《藝想世界》《黑書》《生活月刊新媒體》《殷瑗小聚》《Urban Reserch》《祕境Photo》《文創LIFE》《ELLE》《SENSE》《Here Now》《M.mag》《明周》《Cover Magazine.hk》《秋刀魚》《Upaper》《張老師月刊》媒體報導與專文推薦。

第一本攝影集《院喜》(黑文化)於2015年1月出版，第二本攝影集《院囍》(有鹿文化)2016年9月出版。

Special Event

國立台灣美術館
台中市西區五權西路一段2號

一座島嶼的可能性——2016台灣美術雙年展
院囍——我只是個觀光客

9.10 2016
|
2.5 2017

• 週二-五 9:00-17:00 | 週六、日 9:00-18:00 | 週一、除夕、初一休館

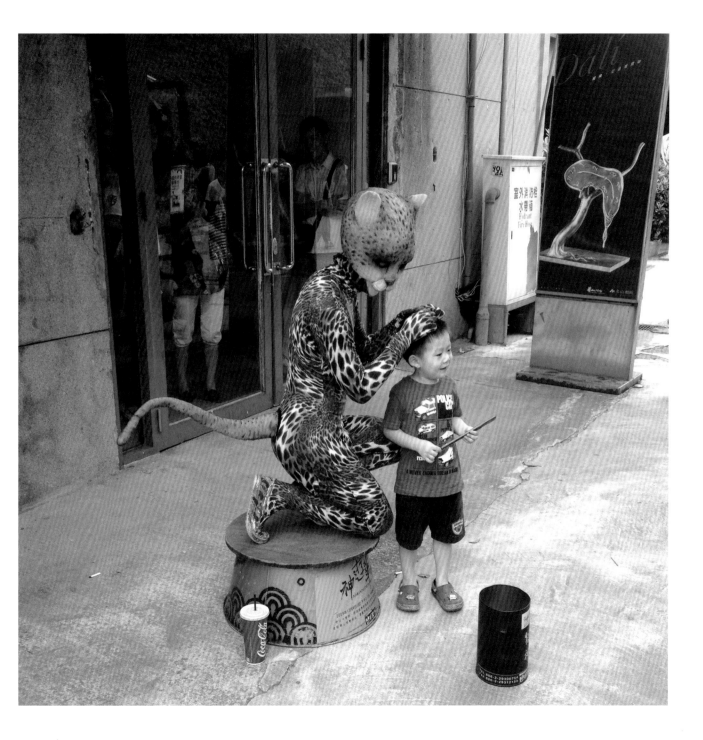

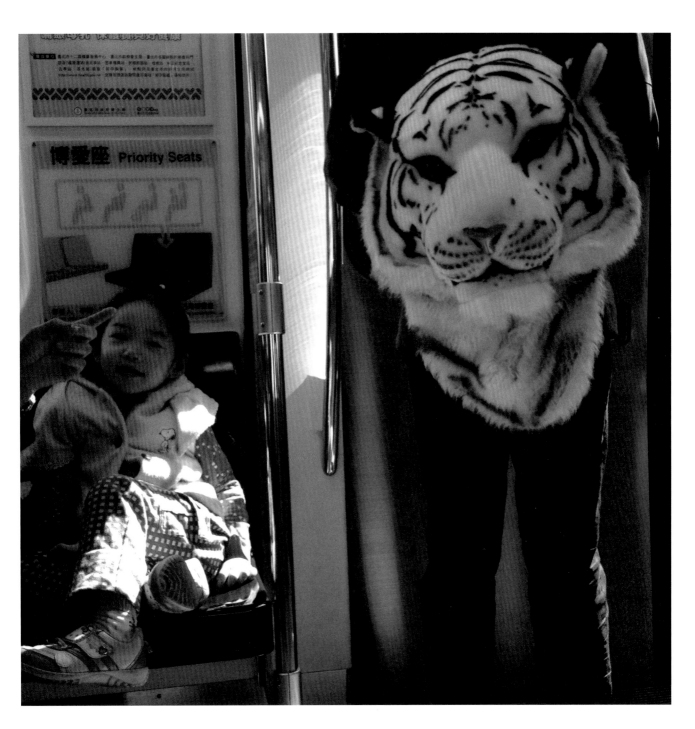

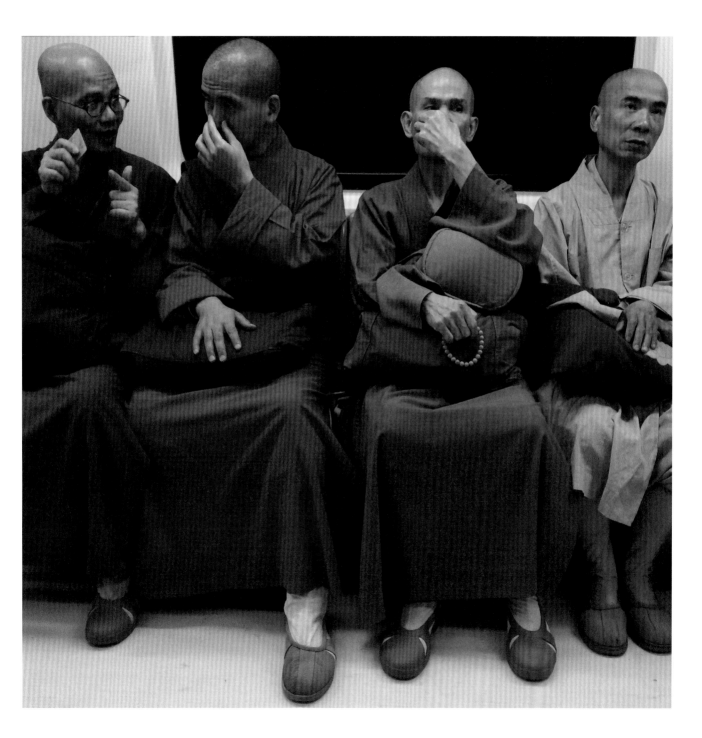

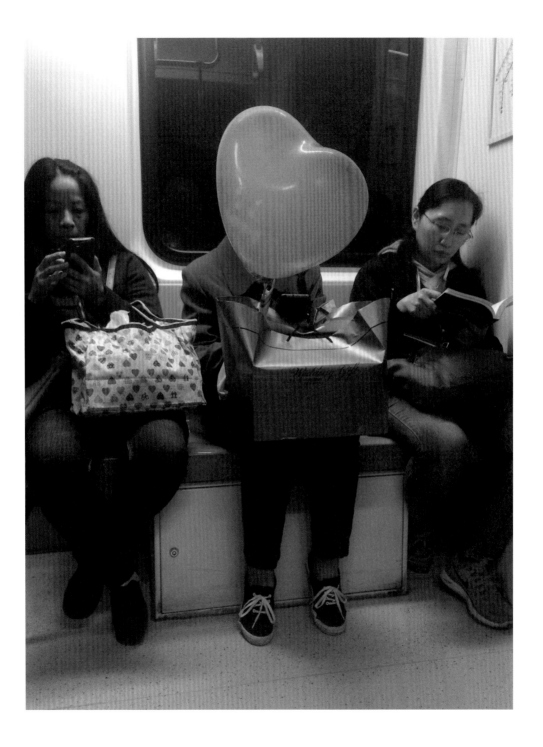

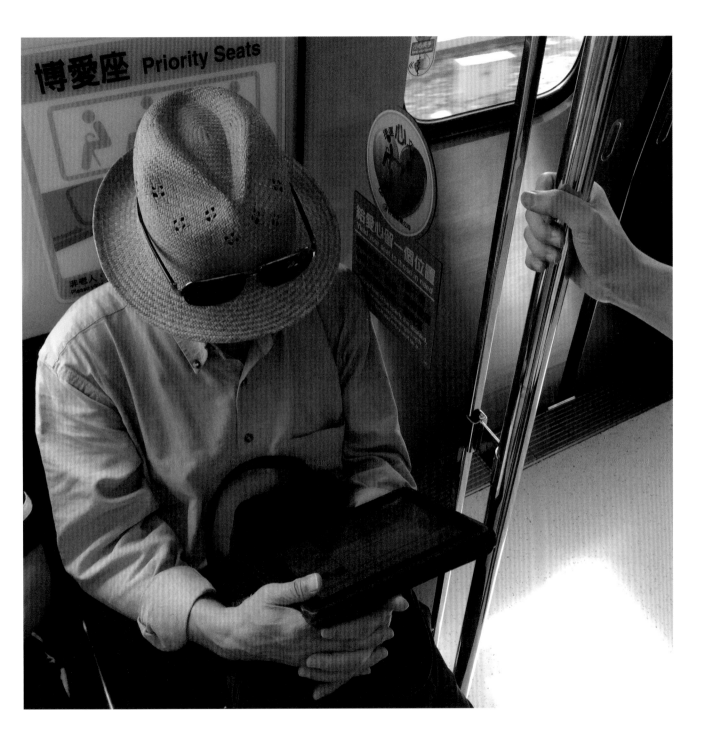

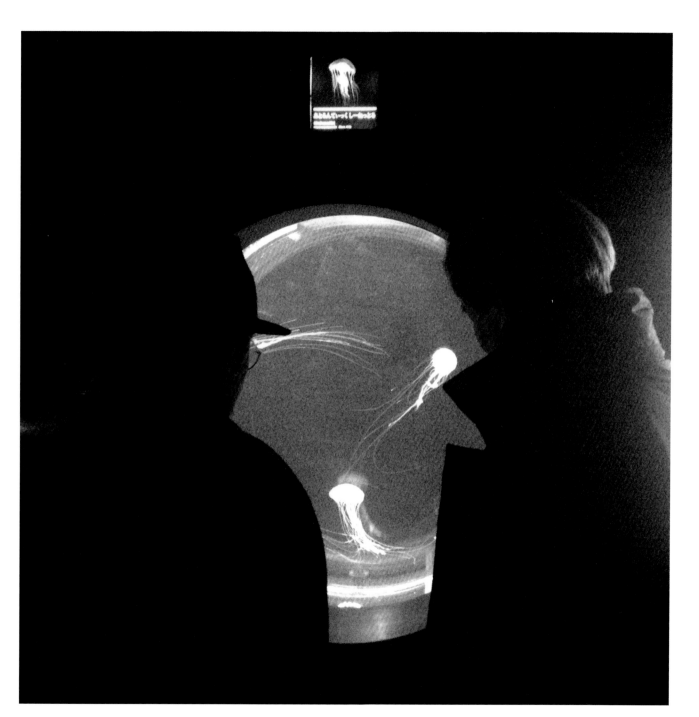

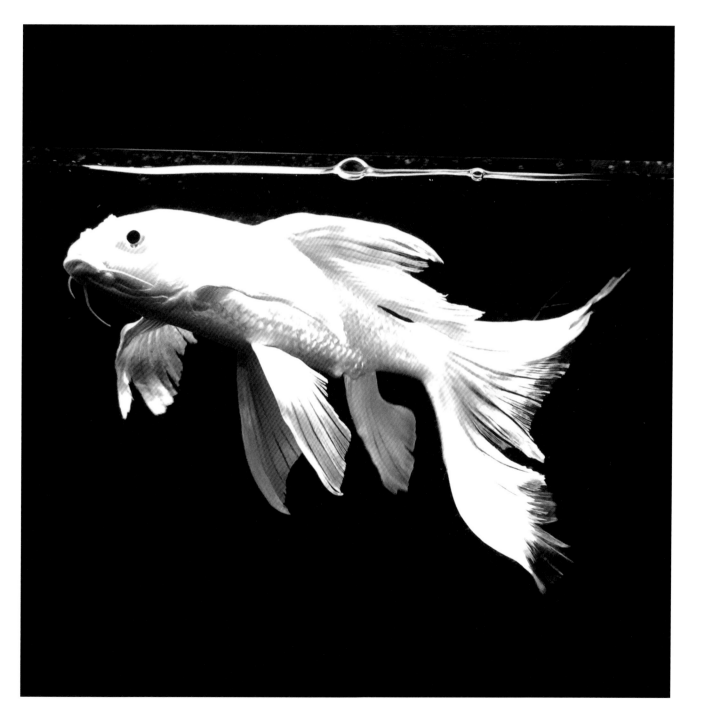

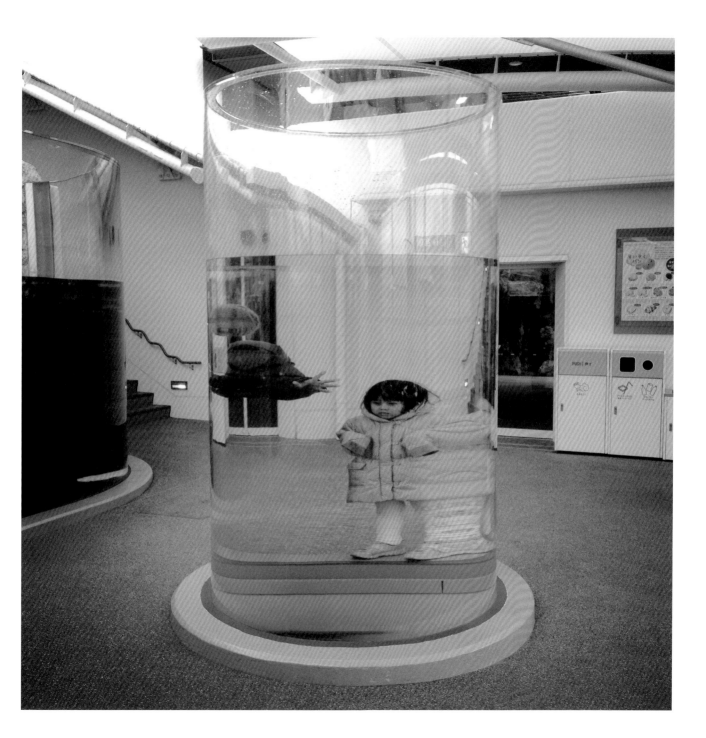

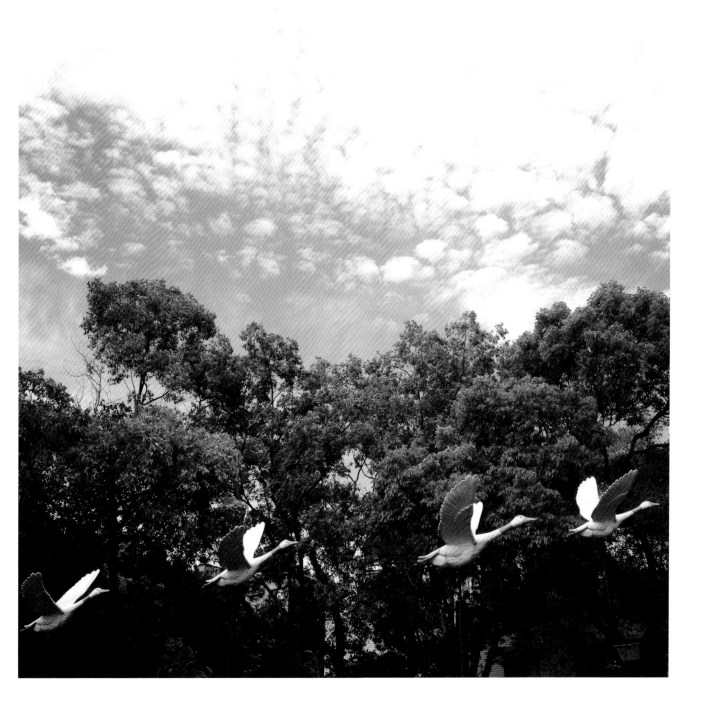

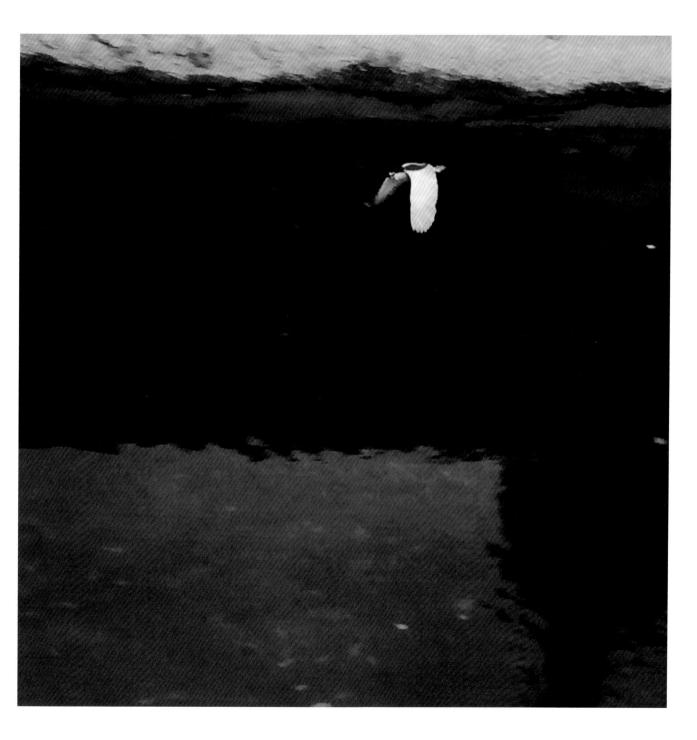

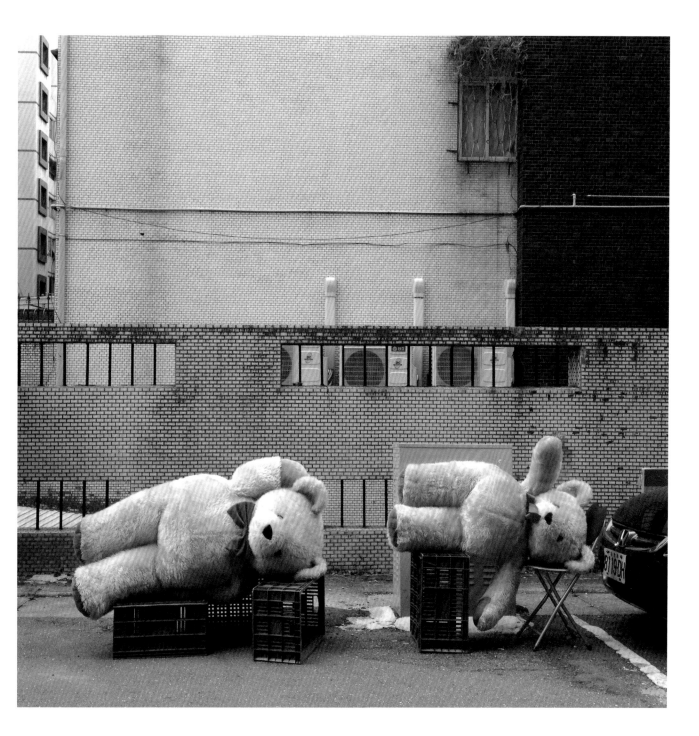

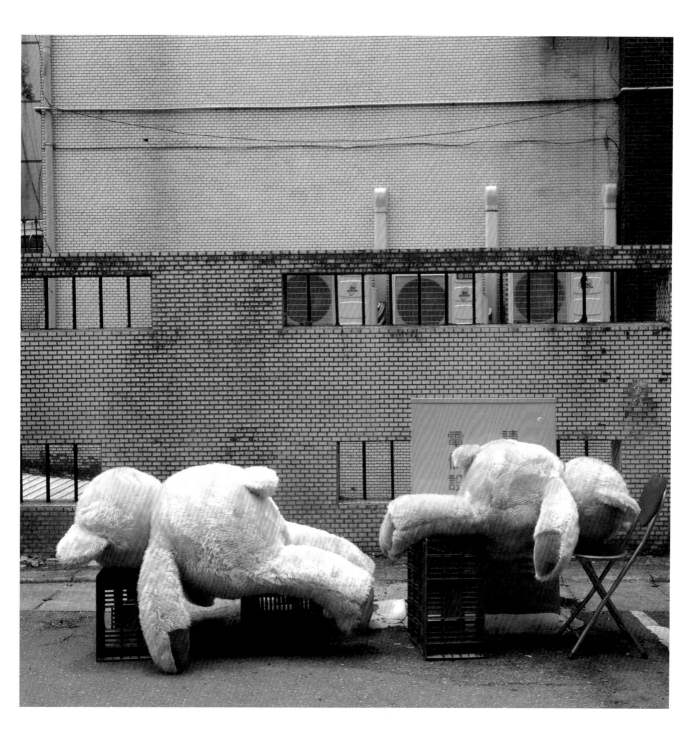

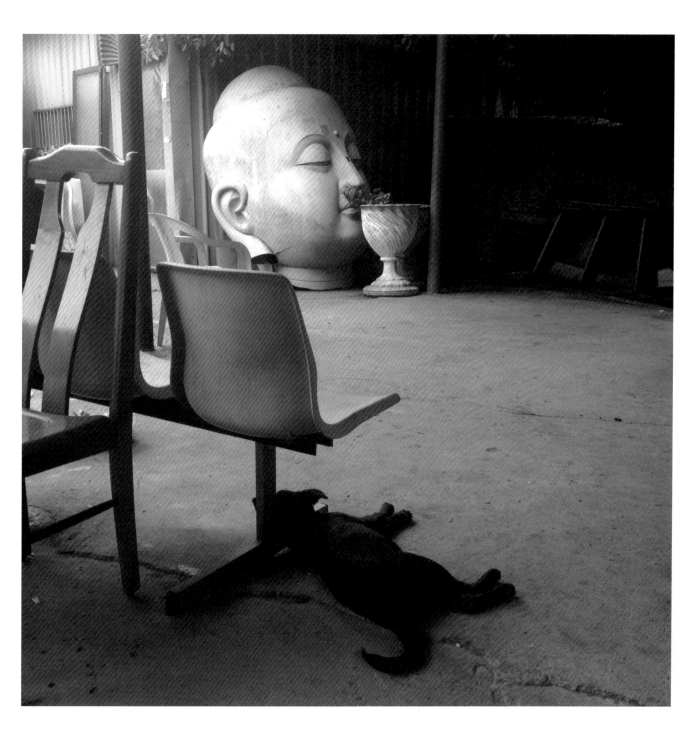

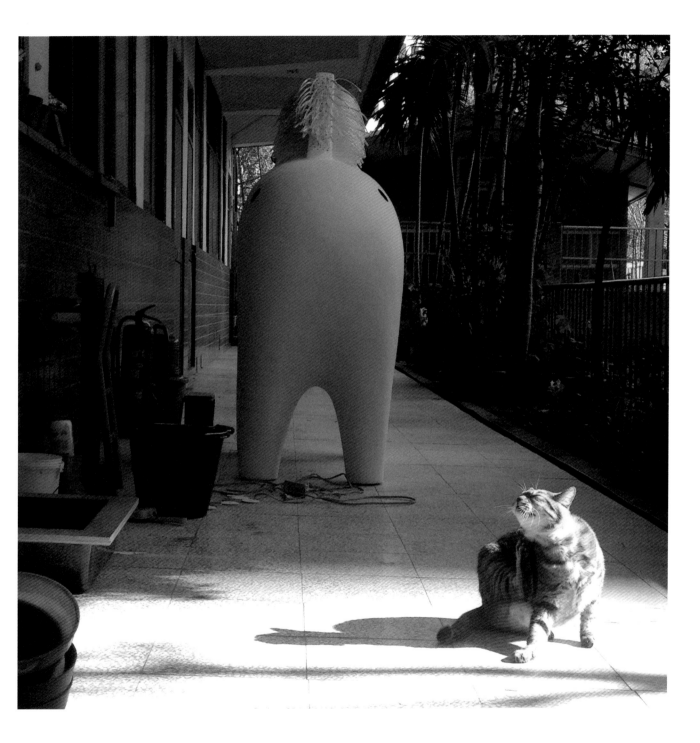

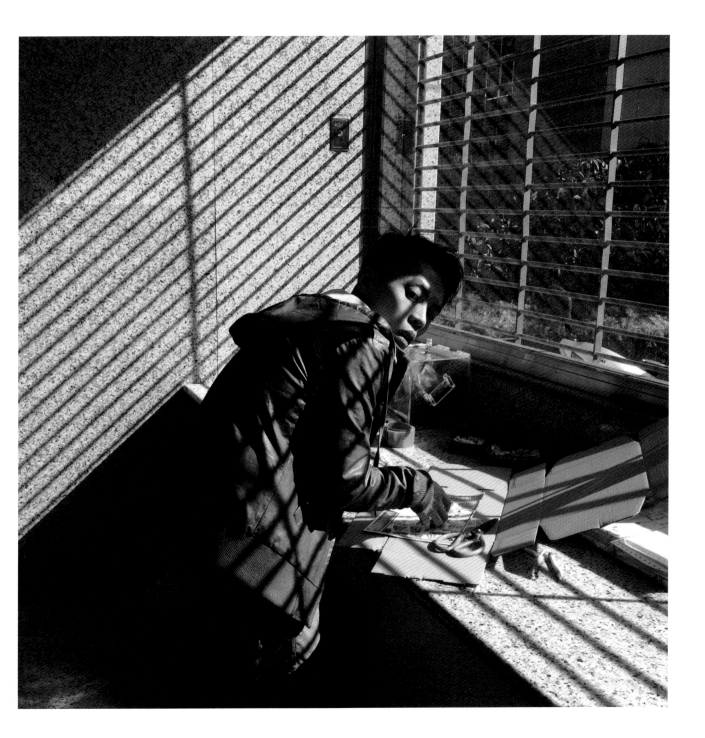

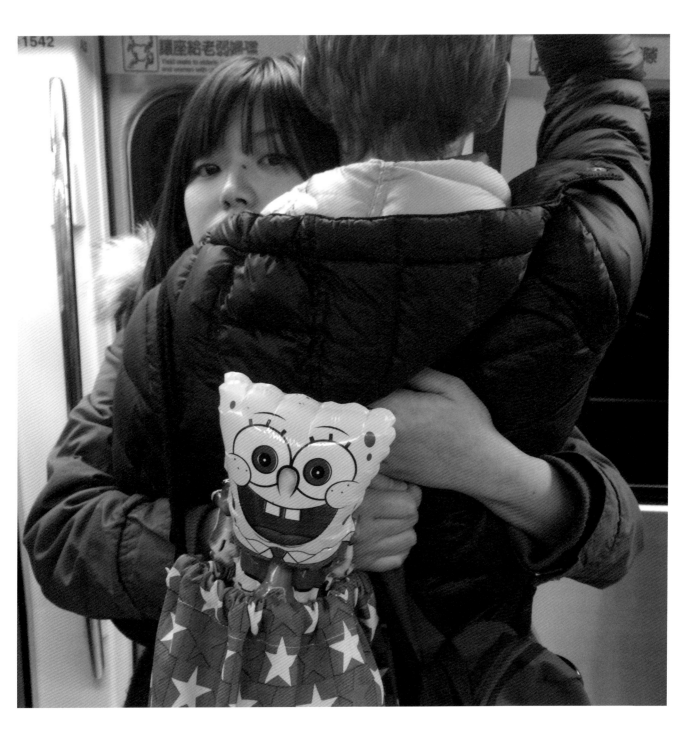

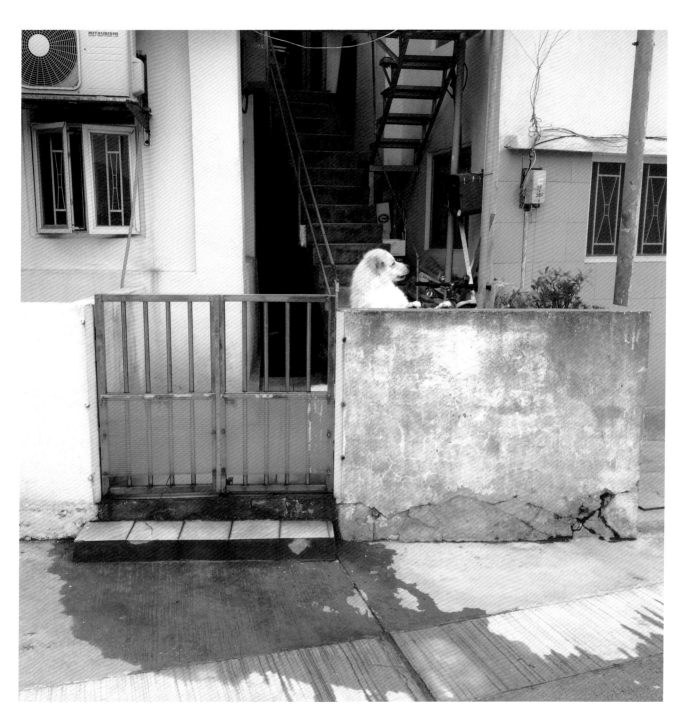

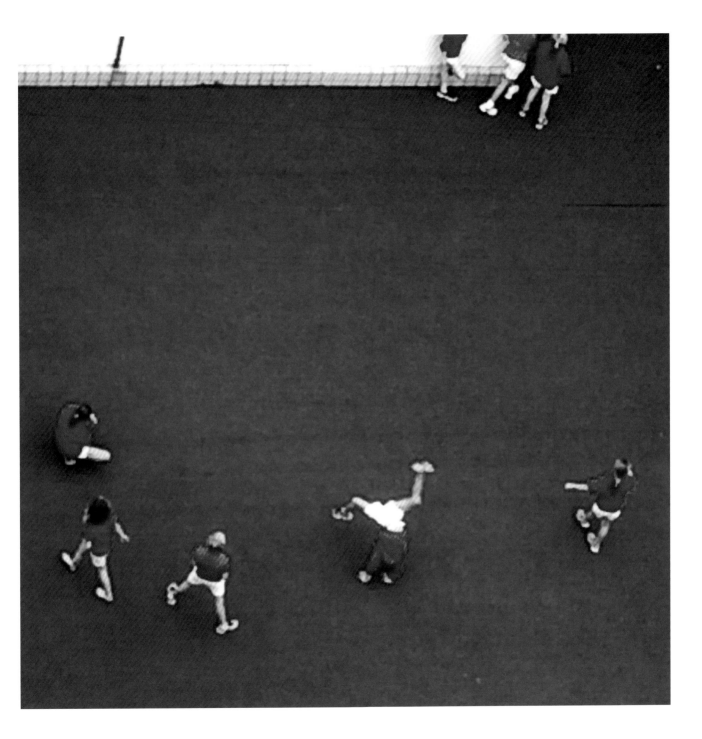

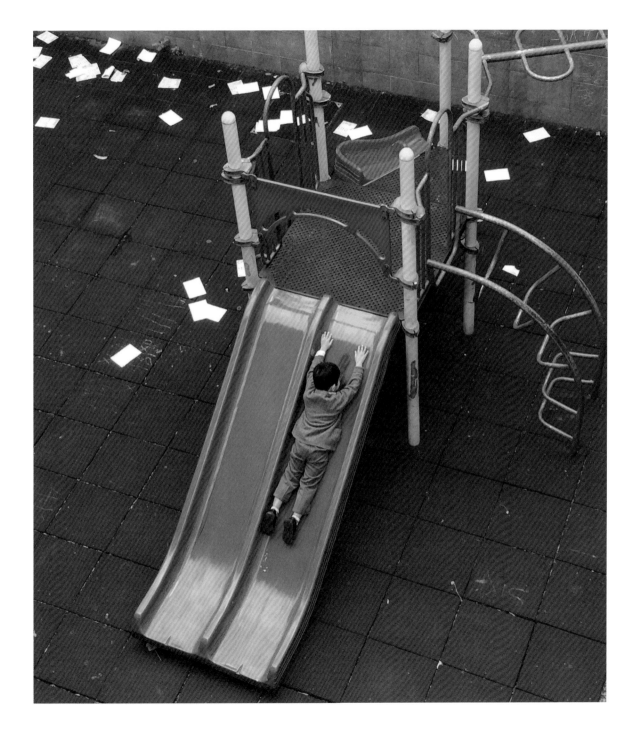

點到為止

黃亞紀 ｜ 亦安畫廊台北負責人

要為這本攝影集寫一段序其實也挺傷腦筋的。首先，優秀的作品本身不需要文字去累贅闡釋。更者，阮璽向來和那些以理論鞏固自己作品意義的攝影家不同，所以根本不該用什麼論述來評介他。

我本來想寫一段詩，但是那太文謅謅了。接著我想可以找一段故事來比擬，但是阮璽攝影的幽默都是完美的斷句，點到為止。最後我看著看著，不知怎麼想起了小時候玩的跳房子——對的，比起技術性地討論正方形構圖，我反而覺得這一格格影像都像是我們兒時畫出的方格。我們專注、屏氣凝神、周遭充斥著其他朋友的喧鬧；我們快速跳著、笑聲、失敗、從頭再來、歡呼。

Scratching the Surface : The Art of Understatement

Huang Ya-chi ｜ Aura Gallery Taipei Branch Art Director

It is not an easy task to write a foreword for this photography collection. To begin with, verbal interpretations are not necessary for superior works of art in themselves. Furthermore, Juan Sea is not one of those photographers who tend to strengthen the meanings of their works by means of theorizing. Therefore, it is virtually pointless to introduce him in the form of discourse.

I had toyed with the idea of writing a poem about it, but that would be too literary. And then I had thought of making an analogy by means of a story, but the sense of humor in Juan's photography, though often understated, is complete in itself. While engrossed in his works, somehow I had an epiphany — this is just like the hopscotch we used to play when we were children. Yes, instead of dwelling on the technical aspects of composition, I felt these little squares of images were more like the grids we drew for the childhood game. We held our breath for concentration amid clamors made by our friends; we leaped and jumped, laughed, failed, then started again, and shouted for joy.

跳房子連結的肯定是微笑，是不做作，是城市裡的童心。藝術如果是冷冰冰的，它就不可能與任何人交流。在當下的藝術圈或攝影圈中，我們最缺乏的就是一個溫暖的核心，這使得藝術變得不是炫技，就是虛榮，結果顧影自憐，最後似是而非。因為我們忘記了藝術的核心源自於相信人，相信自然，相信執著。

我也曾不喜歡阮璽的作品，他也都清楚明白，但他依然使勁堅持，他的努力與誠懇最為可貴。老實說，這本攝影集也不是我最喜歡的阮璽作品，因為我看著他的成長，已見到他還有更精采的作品令人期待。連著兩本攝影集，他發掘的不只是城市裡幽默與意象的串連，更是他自己做為一位獨特攝影家的一條路子。

What is connected through hopscotch must be the unassuming laughter, the inner child in every city dweller. If a work of art is cold, it will not resonate with anyone at all. That is what is lacking, a warm core, in the contemporary art or photography circle, which has led to art being a show-off, a vainglory and navel-gazing act, and consequent inauthenticity. That is because we have forgotten the true heart of art originates in faith for human beings, for nature, and for sticking to what you believe in.

I was not a fan of Juan's works at first, and he knew it. Nevertheless, he kept making tireless efforts and sticking with his art; such hard work and sincerity are hard to come by. Truth be told, this present anthology is not my favorite Juan collection either. That is because I have watched him grow as an artist and know that there are still more exciting works to come. In the two collections he has put out so far, Juan reveals the city's sense of humor in images. Also, he points out a unique path of his own as a photographer.

能否跟大家談談第二本攝影集書名《院囍·Double Happiness in a Courtyard》，跟第一本攝影集《院喜·Happiness in a Courtyard》相比，在創作精神上，是一種延續，還是有所不同？

這本攝影集絕對是第一本的延續，在創作表現上更加精準。坦白說，我有一種感覺，好像在出了第一本攝影集之後，我才真正開始學攝影。以前，我比較像是在父親身邊耳濡目染，獨自摸索，從只是隨性記錄生活，到現在我越來越清楚自己想說的是什麼，能更完整地表達出我是一個什麼樣的人。第一本攝影集出版後，我也一直持續思考攝影對我的意義為何。

Can you tell us something about your second photo collection *Double Happiness in a Courtyard,* whose title unmistakably bears reference to your first collection *Happiness in a Courtyard*? Is it a continuation in terms of creative spirit, or is it somewhat different?

This collection is definitely a continuation of the first one and more precise in terms of creative expression. To be frank, I have always had a feeling that I only began to learn photography after I put out that first collection. In the past, it felt like I had been learning by watching how my father worked and exploring by myself, documenting aspects of my life casually. Now I know what I want to say with my photos more and more clearly, in addition to more fully expressing the kind of person I am. After the publication of my first collection, I have been pondering what photography means to me as well.

本來我還在苦思新作品書名應該是什麼，有天突然靈機一動，何不喜上加喜，變成「院囍」？（第一本一個喜第二本兩個喜，有諧音的趣味，名字也有延續，挺逗的，很符合我的個性。）何況，新作品中，幽默詼諧的確比第一本還多，趣味性也更多。對我來說，這絕對是創作意念上的延續。

你說你是在出了第一本攝影集之後才開始學攝影，是不是表示除了攝影人這個單純角色之外，你在出版過程中，學習到用另一種角度來看待作品？你在編輯過程中學習到什麼？

首先要先感謝阿 Fi，我的第一本攝影集當初是完全授權給他，讓他主導，連我自己看到成果都很驚喜，原來我的作品看起來可以是這樣。書出了之後他把整本《院喜》的圖像編輯概念跟我分享，聽完我就開竅了。當時我知道自己想拍什麼，但還無法具體說明。經過他的分享後，我知道，最有趣的攝影集，都能從中找到一套

I had a hard time coming up with a title for the new collection, but then it dawned on me: why not I repeat the happiness (喜) to make it doubly so? (By repeating the Chinese character [喜] twice, you get a word [囍] with practically the same meaning and pronunciation which signifies a sequential order. Such wordplay is in sync with my natural disposition.) Moreover, the new collection is indeed more fun and humorous than the first one. For me, it is definitely a continuation of creative ideas.

You said you only began learning photography after you had published the first collection. Does it mean that you learned to look at your own works in a new light other than that of a photographer during the process of publication? What did you learn when editing the book ?

First off, I'd like to extend my gratitude to A-Fi, who handled the editing of my first collection and delivered results far exceeding my expectations. He explained the concept of image editing after he finished the whole book, which enlightened me to the art of editing. Back then I knew what I wanted for my photography, but I could not put it into words. After his tutorial, I learned that there must be an inherent narrative logic to an engaging photography anthology. The distribution of photos with varying degrees

敘事的法則。照片強度輕重分布都有意義，有時抽象具象必須兼具。那時我才知道，這就是照片編輯。我也才明白，照片編輯有多麼重要。按下快門之後，攝影並未結束，照片直到開始編輯時，才變得更有意義。我是習慣每天拍照、整理照片的人。會拍照，也一定要會整理照片，這一點十分重要。

大陸媒體黑書（The Black Book）曾在專訪中對你的作品做出一句話點評，「精緻的幽默比深刻的悲傷更罕有」，你自己如何解讀這句話？

幽默跟搞笑是不一樣的。搞笑是當下的開心，笑完就沒有了，幽默卻會讓人持續思考會心一笑，有無限想像空間。在紀實攝影的領域裡，悲傷跟深沉比較多，幽默相對比較少，但這有點像是喜劇悲劇的差別，很多人喜歡看喜劇片，看其中的幽默、戲謔或自嘲。事實上，喜劇在表現上，可能比悲劇更難做得好。

of intensity mean something, and sometimes the abstract and the concrete go side by side. It was then I realized what photo editing is all about and came to appreciate its importance. A photo is not complete with the click of the shutter release button; it takes on more meaning when the process of editing is set in motion. I am used to taking photos and arranging them every day. A photographer needs to learn how to sort out his photos, too. This is very important.

In an interview by "The Black Book," the China-based media platform describes your photography like this: "A refined sense of humor is even rarer than profound sadness." What do you make of this comment？

The sense of humor is different from gags. Gags are meant to make you laugh and that's it, while humor has infinitely more room for imagination and leaves you thinking. In the world of documentary photography, sadness and profundity rule over the comical aspect, but this is more of a difference between tragedy and comedy. Comedy is beloved of many for the sense of humor, jests, and self-mockery therein. In fact, in terms of expression, comedy is more difficult to pull of than tragedy.

幽默也有很多層次，比方我就很喜歡卓別林的電影，或是導演貝尼尼（Roberto Benigni）的《美麗人生》（*La vita è bella*），他們的片子述說生活的苦與悲情，卻用幽默跟正向的態度在看待人生，生活雖苦但還是可以用詼諧更正向的角度迎向生命，給人正面的力量。這種有層次的幽默，才是精緻的幽默。幽默不夠精緻，便會流於形式。真正的幽默，我覺得更像是某種覺悟，某種智慧，能笑看煩惱繼續不斷往前走，我很希望自己可以達到這種境界（笑）。

我想花一輩子的時間宣導幽默這件事，希望能讓大家思考更多元，不是只有悲傷，不是只有深沉。有人曾經問我，你夢想成為攝影大師嗎？我的回答是，我的夢想是成為一位幽默大師。我想把自己，把阮璽發展到極致。

There are many different layers of humor. For example, I love Charlie Chaplin's films as well as Roberto Benigni's *La vita è bella*. Both filmmakers depict the pain and suffering of human existence, but they adopt a jocular and positive attitude in dealing with such subjects. Difficult as life may be, one can still embrace it in a humorous way, bringing some uplifting energy to the whole situation. Layered humor like this is what we call a refined sense of humor. Without such delicacy, humor will end up being a formality. True sense of humor, in my opinion, is more like an epiphany, a kind of wisdom that enables you to laugh at troubles and keep moving forward. I wish I could achieve this feat someday.

I'd like to spend my entire lifetime promoting the sense of humor, making people diversify their thinking and realize that there are possibilities other than sadness and profundity. I was asked once if I had dreamed of becoming a master photographer. My reply was I did dream of becoming a master of humor. I want to develop the potential of the person that is Juan Sea to the fullest extent.

你是一個喜歡分享想法，很容易跟大家打成一片的人，你是否會從別人的互動跟意見汲取過程中，調整自己的拍照角度跟方式？

創作絕對要為自己而做。我雖然喜歡拿著照片問別人看了有什麼感覺，但從未調整自己拍照的方式。我的作品跟大眾算是比較親近，所以可以從觀者的反應中得到更多靈感。比方就有人告訴我，第一本攝影集裡那張吊單槓照片反映了台灣社會現狀：「低頭族、旁觀者、力爭上游者」。藝術作品最大的價值，就是可以讓人停下來駐足思考，當然每個人都有不同解讀，但這樣才是好的。不過這也是攝影最難的地方，因為攝影看起來如此真實，要如何表達隱諱或是無法言喻言語的本質，變成一種挑戰。

Considering the fact that you are a person who likes to share his thoughts and get along with people easily, do you adjust the angles and methods of your photography because of your interactions and exchanges with other people ?

You definitely must create what you want for yourself. Yes, I like to show my photos to people and ask their opinions, but I have never modified my creative process because of this. My photography is relatively accessible to the public, so I can get more inspiration from the viewers' responses. For instance, someone told me that the photo featuring a man doing pull-ups in the first photo collection reflects Taiwan's status quo: it is a society of phubbers, onlookers, and strivers. The greatest value of a work of art lies in its ability to make people stop and think. Of course, people interpret the same thing differently all the time, but that is the way it should be. At the same time, that is the most difficult aspect of photography, for photos look so realistic that it becomes a challenge to convey the obscure or what cannot be described.

我認為「跨界」在當今的藝術創作很重要，跨界才能不斷用新思維來看待自己擅長、喜愛的事情。攝影師如果都只用攝影的邏輯來思考作品，絕對是不夠的，應該從更多生活中其他面向的角度多看、多思考。我喜歡親近大眾，這也是我非常欣賞李安與楚浮電影作品的原因，他們的電影可以做到真正的雅俗共賞，深入淺出，是所有人都能看的作品，這也是我的目標。

Crossover is very important in contemporary art. Only by crossing over into different realms can you constantly continue regarding the things you specialize in and love in a new light. It is never enough for a photographer to approach his works from the viewpoint of photography; instead, he should learn to see and think in more different aspects of life. I love getting in touch with the public, and that is why I admire the films by Ang Lee and François Truffaut, for these two really speak to the connoisseurs and the populace alike. Theirs are works of art for everyone, which is exactly my goal.

你自己最欣賞、奉為學習典範的攝影大師是誰？ 他們的攝影為什麼特別？

我立刻想到的是艾略特‧歐維特（Elliott Erwitt）。我覺得自己的攝影面向有三個：溫暖、幽默以及不尋常，然後以一種魔幻寫實的方式呈現。有人說，你就專注拍幽默照片就好，何必還心想著溫暖的、不尋常的照片？但這三種面向其實都是我。

歐維特了不起的地方，在於他的作品同時納含溫暖、美的，以及最重要的幽默特質，並且將這樣的特質推向極致。除了歐維特，我也很喜歡須田一政作品中的弔詭與不尋常。這兩位攝影家，正好分別反應出我個人的三種面向。

Who are your heroes and models in photography ? What makes their photography special ?

Who immediately came to mind is Elliott Erwitt. I always feel there are three aspects to my photography: warmth, sense of humor, and unusualness, which are presented in a magic realist manner. Some said to me, why don't you just focus on making those humorous photos instead of dwelling on those warm, unusual ones as well? In fact, these three aspects are all me.

Erwitt is great in that his works encompass the qualities of warmth, beauty, and — most important of all — humor, and using them to the fullest extent. Aside from Erwitt, I also admire Issei Suda for his strange and paradoxical works. My admiration for these two photographers reflects the three different aspects of mine.

從手機攝影到現在開始以底片相機創作，拍照的方式、觀看的角度是否有所轉變？

有人覺得我只是利用手機的便利，占了「手機攝影」這個風潮，這是很多人對我的誤解。我跟很多攝影人，在器材使用的歷程來說正好相反。我是先從手機開始，後來到數位相機，之後才回到底片。

直到現在，我還是覺得，作品好不好，跟非得用什麼器材一點關係都沒有。我用手機拍照時，許多人問我為何不用（數位）相機，等到我開使用底片，又有人問我為什麼不用手機就好。我之所以會開始嘗試相機、底片，是因為覺得自己必須進步，想嘗試不擅長的領域，從中成長。我的想法其實很單純，既然已經確定一輩子都要拍照了，那我總會有時間學會用各種方式來拍照。

Starting with smartphone photography and now moving on to film photography, have you changed in the way you take pictures and look at things ?

Some people got the wrong impression that I took advantage of the convenience of smartphones, riding on the trend of smartphone photography. My evolution in equipment is contrary to that of most photographers. I started with smartphones, moved on to digital cameras, and then returned to film cameras.

Even now, I still do not think any particular equipment is essential to the success of a photo. When I shot with smartphones, people questioned why I did not use a (digital) camera, and when I started shooting on film, people asked why I did not just use smartphones instead. The reason I started experimenting with cameras and film is that I wanted to grow and make progress by trying out unfamiliar things. It was really very simple. Since I made up my mind to turn photography into a lifelong pursuit, I have all the time in the world for all manners of photography.

我覺得「手機攝影」這個名詞最終會消失，當手機拍照發達、普及到某種程度，就不會有人特別關注照片是用「手機」拍，就像底片時代的人，不會說自己是底片攝影一樣。最終還是回到作品本身。

父親阮義忠先生，幾乎一生都專注於黑白攝影，是否也會考慮朝黑白攝影，或是黑白暗房作業的方向邁進？

我對任何可能性都不設限，但我的確把黑白暗房這件事看得很慎重。我的父親從不直接教我攝影，但也許正因如此，我才能走出一條屬於自己的路。我是個手藝不巧跟好動的人。所以暗房作業對現階段的我來說，會是個難題。現階段的我比較想按快門，待在暗房對我來說，是一種修行的儀式。但我相信未來當我慢慢學會暗房手藝之後，才是真正的父子傳承，我也會更加了解父親的作品。雖然不是現在，但我想快了。

I think the term "smartphone photography" will eventually become obsolete. With the inevitably expanding prevalence of this practice, people will no longer be concerned whether a photo is taken with a smartphone, just as no one would specify they shot on film in the age of film cameras. In the end, it is the work itself that counts.

Your father, veteran photographer Juan I-Jong, has dedicated himself to the art of black and white photography. Will you consider pursuing similar methods or darkroom processing ?

I will not say no to any possibility, but I do take black and white processing in the darkroom very seriously. My father has never directly taught me how to take photos, and maybe that is why I am able to lay down my own path. I am not a handy craftsman, so darkroom processing may pose a serious challenge to me at present. Now I prefer pressing the button and taking the shot. Staying in the darkroom is a sacred practice that I have yet to master. But I believe as I acquire advanced darkroom skills in the future, I will get to understand my father's art better, and that is the true father-son bonding. Not now, but soon.

目前的我拍照節奏已經開始趨緩，下一本作品應該就會著重在底片作品，而在那之後，我也許會開使用中片幅底片、黑白底片。目前的拍照方式，比較像是在城市間遊走，之後也會考慮駐點，希望可以放慢腳步用更深刻的眼光來看世界並做有主題性的拍攝。

在第一本攝影集，你在作品中大量使用了濾鏡軟體。在新作品裡，你好像對濾鏡使用有了新的體會，是什麼？

我還是覺得，不好的作品，濾鏡也幫不上忙。但我現在比較喜歡自然一點的色彩。第一本作品集中的色調，現在來看，似乎有點太濃烈。我有位朋友跟我說這就像一般人品嚐食物，可能只會吃到糖、醬油等調味料，但美食家吃的卻是食材的鮮美，或許我現在更重視的是作品的內容本身了。

I have slowed down in my pace of work, and I think I will focus on shooting film photography for my next anthology. After that, I may begin taking pictures using medium format and black and white films. My way of taking pictures now is more like wandering among cities. Going forward, I will consider staying in one place, taking a slower, more profound look at the world and making thematic photography.

You used filters profusely for photos in your first collection, and it appears that you have come to a new understanding of such effects in the new one. So what is that ?

I still think a bad photo cannot be helped by adding filters to it. As I have come to prefer more natural colors, the tones in my first collection now seem a bit too strong. A friend of mine told me it is just like tasting food. While ordinary people taste seasonings like sugar and soy sauce, a gourmet tastes the pure flavors of the ingredients.

我現在也還是會用濾鏡，但對自己的作品更篤定了，已經不需要太過度的濾鏡效果來調味。濾鏡只是表達我對這張照片的某種感受，但我現在更喜歡簡單、耐看的畫面。故事夠好，就不需要華麗的詞藻來裝飾。我把先前一些作品拿掉濾鏡效果之後重新看，好像是全新的作品一樣，有了不同的意義。

兩岸新一代的攝影人，在思考脈絡以及呈現手法上，是否有顯著差異，對應到各自不同的文化背景？

我的看法是，台灣新一代攝影人普遍追求「形式」。台灣的攝影作品，在內容的多元性比較欠缺。攝影師最難的就是透過作品表達出自己的性格。我可能因為之前做過許多工作的關係，大量與人接觸，生活體驗多些，知道自己想要說的是什麼。

I still use filters, but as now I am more certain of my own photography, I do not rely on excessive use of effects to spice up my works. Filters are merely used to convey my own feeling about a particular photo, but now I prefer a simpler, less showy picture, just like a good story does not need embellishing with pretty words. After I removed the filter effects from some of my old photos, they look like entirely new works with totally different meanings.

Are there visible differences between new-generation photographers on both sides of the Taiwan Strait ? Do they differ in terms of thinking and expression in accordance with their disparate cultural backgrounds ?

The way I see it, the new generation of Taiwan photographers tends to emphasize on form in general, and local photography somewhat lacks diversity in terms of content. The most difficult part of being a photographer is to express his or her personality through works. As I worked different jobs before taking up photography, I got to interact with a lot of people and have more diverse life experiences. Maybe that is why I've always known what I want with my photography.

缺乏生活體驗的年輕攝影師，作品比較容易流於形式。比方說，我們當然可以追求「決定性的瞬間」，但布列松之所以了不起，是因為他的風格與形式完美結合，在表達故事的同時，使用了這樣的攝影手法。台灣年輕攝影師比較會有形式重於內容，風格不夠多元的問題。

我覺得大陸的年輕攝影師，作品傳達出來的是一種「茫然」，好像對未來跟自身有太多的不確定性。但茫然也是一種感覺，至少會從作品中感受到他們對自身與環境的了解，他們用攝影與其對話。相對作品就比較深沉，深刻得多。

Young photographers with relatively less life experiences tend to produce works big on form. Sure, a photographer can pursue "the decisive moment" like Henri Cartier-Bresson, but Cartier-Bresson was able to pull it off because of his perfect combination of style and form. That is why he was able to create "the decisive moment" while telling a story. The lack of diversity in style due to emphasis on form over content is a common problem with many Taiwanese photographers.

Meanwhile, the works of many young Chinese photographers exude a certain uncertainty, possibly about the future and themselves. But uncertainty is also a kind of feeling. At least you can feel that they do try to understand themselves and their environment; they engage in dialogue with them through photography. In comparison, their photography is deeper and heavier.

As a photographer, do you think of being different from other people all the time ? Is there anything you can share with new photographers seeking to take up the profession ?

做為一位攝影師，你是否無時無刻不想著要和別人不一樣？ 是否有什麼心得，可以和想進入攝影世界的新朋友分享？

我的想法比較特別，人為什麼要怕跟別人一樣呢？不一樣不一定會好，但夠好就一定會不一樣。每個人都可以在自己熟悉、喜歡的領域裡做到極致。但也不是悶著頭去做，必須花心力去了解別人曾經做過什麼事。

再來就是堅持。堅持不是別人做過什麼東西我就不要，而是相信自己做的東西。不要怨嘆沒有伯樂，也不要輕易改變攝影的初衷與想法。作品不好不是別人的問題，是自己的問題。

此外，一定要跨界，用不同的面向，跳脫攝影的思維來思考，從更廣的面向，從音樂、文學、藝術等等中去思考。能從自己的生活中學攝影才是最好的。

I may have a little bit different idea about this. Why be afraid of being the same as other people? Being different does not mean you are necessarily good, but being good enough does make you different. Everyone can choose to do his best in a field that he likes and is familiar with. But that does not mean you just throw yourself into it. You have to make efforts to understand what have gone before in that particular field.

Then you have to stick to your art. It does not mean discarding anything that people have done before but believing in what you do. Do not whine about how no one really appreciate your art, and do not change your core values and ideas about photography too easily. It is nobody's problem but yours in producing unsatisfactory works.

In addition, you must branch out. You must step out of the confines of photography and think differently in a wider spectrum, from the perspectives of art, literature, music, and so on. It will be best if you can learn photography from your own daily life.

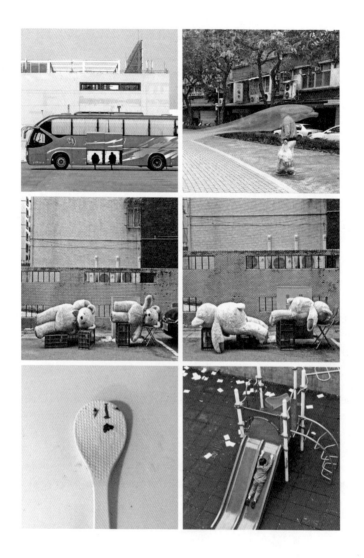

可否與大家分享幾張作品背後的創作故事？

1

一次我跟父親到上海浦東機場，接機的車子在停車場收費站繳費時，我跟父親透過車窗同時看到一個畫面：有部大客車，兩邊行李箱門同時都打開，兩個穿著制服的司機，坐在邊上，翹著同一隻腿，低頭正在吃便當。我隨即拿出手機，父親也立刻拿出相機。但父親看了一下觀景窗後就把相機收起來了，因為相機變焦長度大概不夠。但對我來說根本是奇景，也是最能代表我的風格的畫面，不管三七二十一，把手機鏡頭變焦拉到最遠拍下。當下知道解析度一定不夠好，但我知道重要的是有沒有拍到當下的氛圍。

後來有一次跟父親合辦講座，我把照片放在簡報最後一張。父親看到之後會心一笑，什麼話都沒說。那是兩個攝影師之間的一個有趣時刻，父子兩人透過攝影，對所看到的畫面做出不同的回應。

Can you share with the readers origin stories behind some of your photos ?

1

Once I went to the Shanghai Pudong International Airport with my father. When our driver stopped at the tolling station, my father and I saw the same picture through the car window: a bus with both luggage compartments opened, revealing two drivers in uniform sitting on the side, legs crossed, and eating their lunch. I took out my mobile phone right away while my father produced his camera. But my father put it away after taking a peek in the viewfinder, for I guess he needed a longer focal length lens to capture it. For me, however, this was an opportunity for a miracle shot, perfect for my style. So I zoomed out as far as possible and took the shot. I knew right then the resolution would not be good enough, but what mattered was whether I caught the moment in time.

Later, at a joint talk I gave with my father, I showed this photo at the end of my presentation. My father smiled knowingly at the sight of this, without saying anything about it. That was a moment of complicity between two photographers. Father and son responded to the same picture in different ways through photography.

2

這張照片攝於台北中山北路當代美術館附近。那裡有個地景裝置藝術，許多薄紗繫在金屬物上，薄紗很長，一直隨風飄逸。

我其實並不清楚裝置藝術的設計意圖，但應該是想要跟來來往往的行人互動，所以我就想拍下薄紗跟人互動的瞬間。我在那裡等了一會兒，等到一個拿著藍色垃圾袋的男子走了過來，藍色薄紗正好飄在他的臉上，跟垃圾袋又相互呼應，畫面正好有一種突兀的幽默感，於是就拍了下來。

3 + 4

之前我曾在二手家具店工作，當時隔壁的店裡放著兩隻可愛的巨型玩偶熊。有一天，隔壁的店員在門口搭起了架子曬熊，我看到時笑個不停，可是路人似乎沒有太多反應。

2

This shot was taken somewhere near the Museum of Contemporary Art in Taipei City. There was a landscape installation in the neighborhood, which featured long gauzes suspended on metal structures, flowing freely as the wind blew.

In fact, I did not quite grasp the design intent of this piece, but I guess it was supposed to interact with people walking by. So I set out to capture the moment the gauze engaged in such interactions. I waited a while and saw a man carrying a blue trash bag come over. The flying blue gauze happened to cover his face, accentuating the blue trash bag in his hand. There was a kind of abrupt humor in this scene, so I released the shutter and took the picture.

3 + 4

I used to work at a used furniture shop, and there were two giant stuffed bears next door. One day the clerk put them out to dry in the sun. I could not stop laughing when I saw this, but the passers-by did not seem to register the fun of it all.

The most interesting thing about photography is that when you see something extraordinary out of something ordinary, you find

攝影最有趣的地方之一，就是在平凡的景物當中看到不平凡的特質，把畫面定格下來再看，會比本來有趣得多。那天早上我拍下一張曬熊照，下午時發現熊竟然翻身了，當然再拍一張。後來有一天跟隔壁店員聊天，我找出曬熊照，他看了大笑，我想他也沒意識到，這麼稀鬆平常的一件事，在畫面上看起來竟是充滿趣味。

5

前兩年，我有一段時間吃素，那也是我開始認真拍照的時刻。那時的我，不曉得為什麼，感官非常敏銳，總覺得可以在生活不同畫面中不斷看到一張張奇特的臉。

這張照片是在家裡拍的。那天媽媽做了菜飯，本來順手就把攪拌完的飯匙丟進水槽裡清洗，結果進廚房，一眼就看到飯匙上頭的一張臉，當下趕緊救回飯匙，拍下照片。後來很多人覺得很像京都有名吸油面紙的形象，我聽了哈哈大笑覺得很貼切。

it to be even more interesting when you capture a still image of it with the camera. I took a picture of the sunbathing bears that morning and was surprised to find them turned over in the afternoon. Of course I took a second picture of the scene. Later in one of our conversations, I told the clerk next door about the incident and produced the photos of the sunbathing bears. He burst into laughter at the sight of them. I guess he did not realize how something so ordinary could appear so fascinating in the photos.

5

I went vegetarian for some time a couple of years back, and that was when I really started to take photography seriously. I don't know why, but I was extremely sensuously alert then, always able to spot unique features in different scenes of daily life.

I took this photo at home. My mom made steamed rice with vegetable that day and left the rice scoop at the kitchen sink for cleaning later. I immediately spotted the face on the scoop as I entered the kitchen. I salvaged the scoop right then and took a picture of it. Many people who saw the photo said it resembled the face logo of a famous facial oil blotting paper brand (Yojiya) based in Kyoto. I laughed so hard hearing that for it was verily so.

6

這張照片攝於香港跑馬地。跑馬地有個墓園，入口在山腳下，出口在山頂，我想那就先爬到山頂再進墓園一路往下，這麼一來，外圍跟內圈就都走遍了。

在外圍半山腰，我突然看到一間錫克廟，裡面有一間學校，一群小朋友正在遊樂園嬉戲。他們穿著整齊的制服，玩得很瘋，甚至開始撕起紙或是課本。這時上課鈴聲響起，小朋友跑回教室，但就是有一位小朋友不走，老師拚命招手，這時就看到他爬上溜滑梯，一副就是要再溜最後一次的樣子。我開始等待，看到他竟然是頭朝上趴著往下溜，紅色領帶往上飄，好像小朋友吐血或是命案現場畫面。拍出這種超出預期的結果，感覺真的很棒。

6

This one was shot in Happy Valley, Hong Kong. There is a cemetery in Happy Valley with the entrance at the foot of the hill and the exit at the top. So I planned to go up the hill first and come all the way down. That way I would be able to circle the entire cemetery.

At the outer circle of the cemetery on the mountainside, I came across a Sikh temple, where there was a school and children playing in the playground. They were all neatly dressed in uniform, and they were having a hell of fun, even tearing off pages from the textbooks. Suddenly the bell rang, and they rushed back into the classrooms. A schoolchild, however, was reluctant to go even as his teacher signaled him to come back in. At this point he climbed up the slide, ready to make one last go at it. I waited there and saw him slide down on all fours, with his red tie flying upwards. The whole picture looked like a murder scene, like the little kid was spilling blood. This shot was truly beyond my imagination, and it felt really great.

後來我跟香港朋友聊天，覺得自己好像拍到了香港的社會現狀，呈現出香港小朋友辛苦壓抑的一面，拍到了象徵意義，或是一種社會縮影。這張照片，足以代表我心目中的街頭攝影。對我來說，街頭攝影就是看、觀察、等待，然後加上好運，有時結果好得超出自己本來的預期。街頭攝影師都愛講一句話：「我總是運氣好。」可是我覺得街頭攝影師，一定要相信自己能夠拍到好畫面，不相信的話，就沒有可能性。

街頭攝影師需要一點衝動跟傻勁，喜歡就去試。有一句話是這麼說的：「你不需要很厲害才能開始，但你需要開始才能很厲害。」拍照的人，其實不是在享受那一張的好運，而是在享受無數張作品背後探尋的過程。但是沒有一再嘗試與累積，好運就不會憑空出現。

Later I talked to my Hong Kong friend and had a feeling that I somehow captured a slice of reality in this society, showing the deep repression harbored by the schoolchildren of Hong Kong. It was like an epitome of the society. This photo sums up my idea of street photography. For me, it is watching, observing, and waiting, added with a little luck, which sometimes produces results far exceeding one's expectations. "It's all just a stroke of luck," street photographers like to say. But I think a street photographer must believe he can capture the perfect shot, or there just will not be any such possibility.

Street photographers must have a little impulsive and silly side to them, trying out anything they fancy. A saying goes, "You don't have to be really good to start, but you must start somewhere to get really good." We photographer do not take pleasure in finding luck with that one shot; rather, we take pleasure in the process of searching behind countless shots. Luck will not present itself without the accumulation of trials and experiences.

光遷 005

院 囍

作者　　　　阮　璽

美術設計　　吳佳璘
訪談整理　　林煜幃
訪談翻譯　　陳逸軒
責任編輯　　林煜幃

董事長　　　林明燕
副董事長　　林良珀
藝術總監　　黃寶萍
執行顧問　　謝恩仁

出版　　　有鹿文化事業有限公司
地址　　　台北市大安區濟南路三段28號7樓
電話　　　02-2772-7788
傳真　　　02-2711-2333
網址　　　www.uniqueroute.com
電子信箱　service@uniqueroute.com

製版印刷　中茂分色製版印刷事業股份有限公司

總經銷　　紅螞蟻圖書有限公司
地址　　　台北市內湖區舊宗路二段121巷19號
電話　　　02-2795-3656
傳真　　　02-2795-4100
網址　　　www.e-redant.com

國家圖書館出版品預行編目(CIP)資料

院囍 / 阮璽著
一初版. 一臺北市：有鹿文化, 2016.9
面；公分.一(光遷；005)
ISBN 978-986-93289-3-7 (平裝)

953.33　　　　　　　　105014181

ISBN：978-986-93289-3-7
初版：2016年9月

定價：450元
版權所有・翻印必究

Double Happiness in a Courtyard

Author　　　Juan Sea

Designer　　Wu Jia-lin
Translator　Chen Yi-hsuan
Editor　　　Lin Yu-wei

Publisher　　Route Culture, Ltd.
Address　　　7F, No.28, Sec.3, Jinan Rd., Da-an Dist.
　　　　　　　Taipei 10651, Taiwan
Tel　　　　　+886-2-27727788
Fax　　　　　+886-2-27112333
Website　　　www.uniqueroute.com
Email　　　　service@uniqueroute.com
Distributor　Red Ants Books Co., Ltd.
Printed by EliteColor Reproductions & Prints

ISBN：978-986-93289-3-7
Price：NTD 450

© Route Culture, Ltd. 2016